How to Draw
Vintage Dresses

VOLUME 2

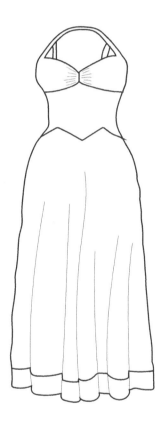

Designed and Illustrated by Beth Ingrias

Copyright 2017 Team of Light Media LLC
All Rights Reserved
ISBN-13: 978-1978308114
ISBN-10: 1978308116

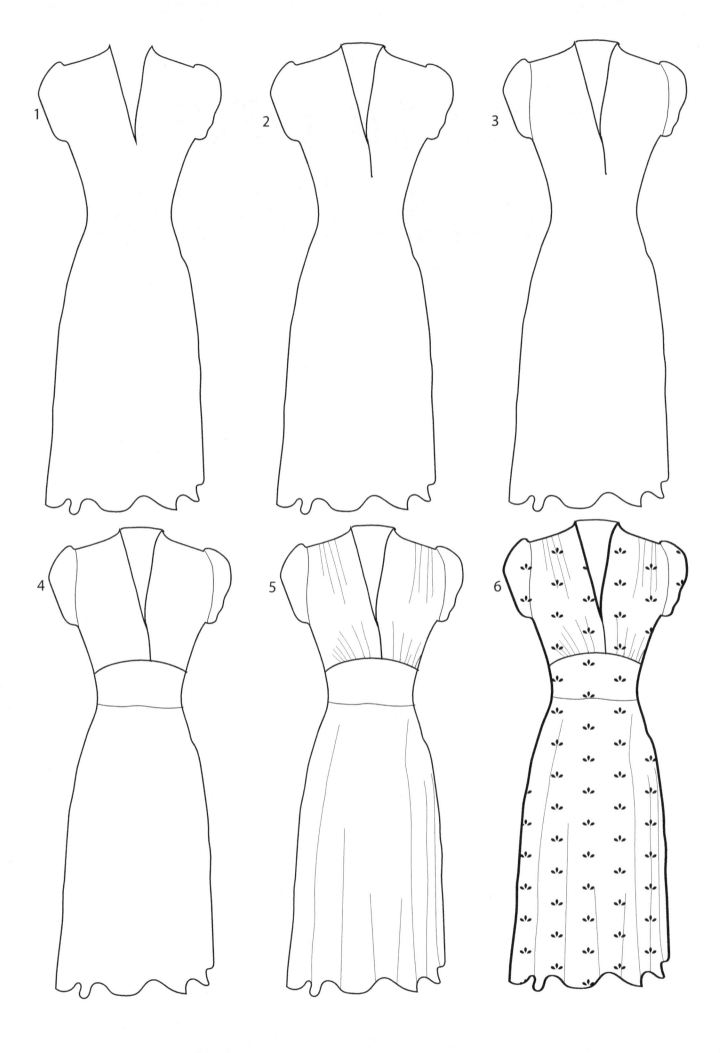

Practice Page

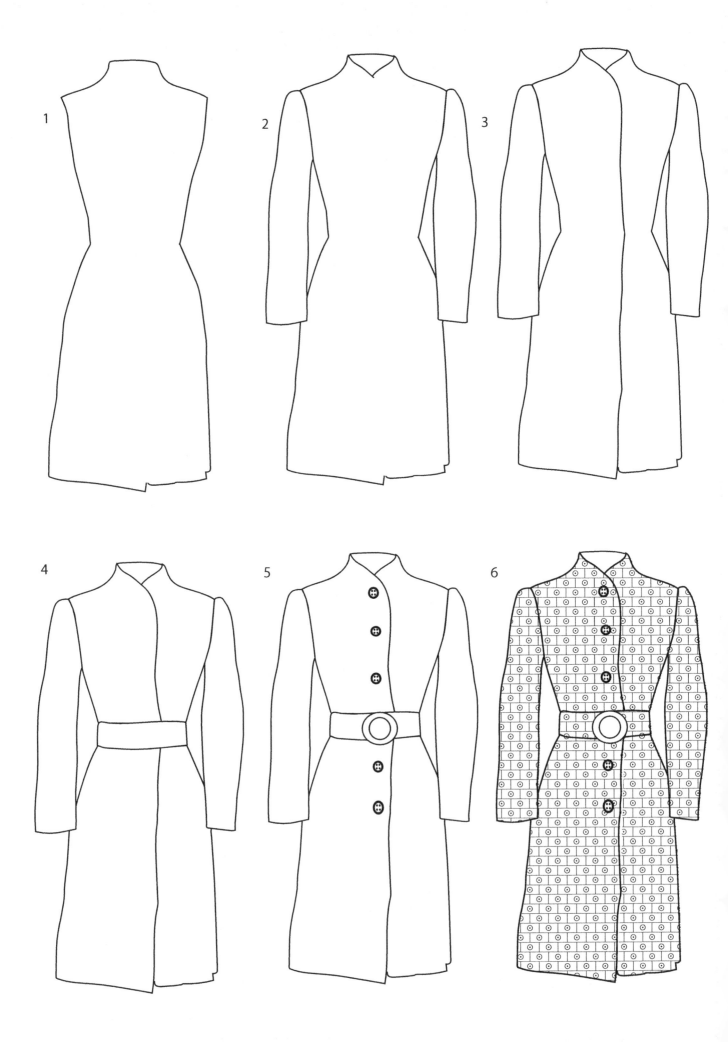

Practice Page

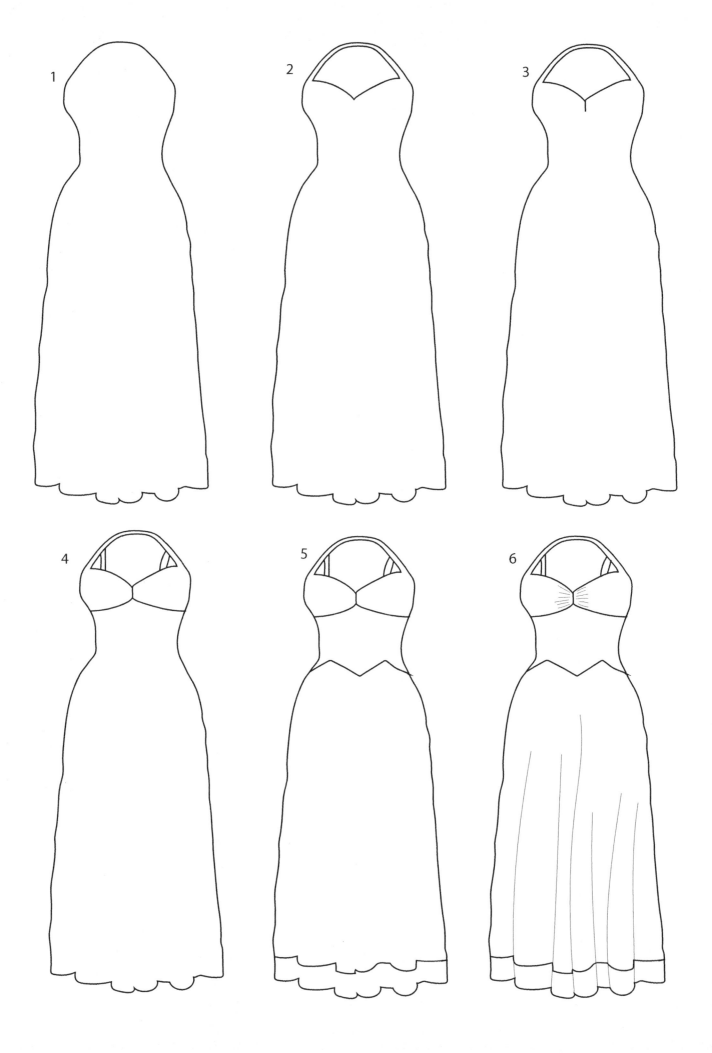

Practice Page

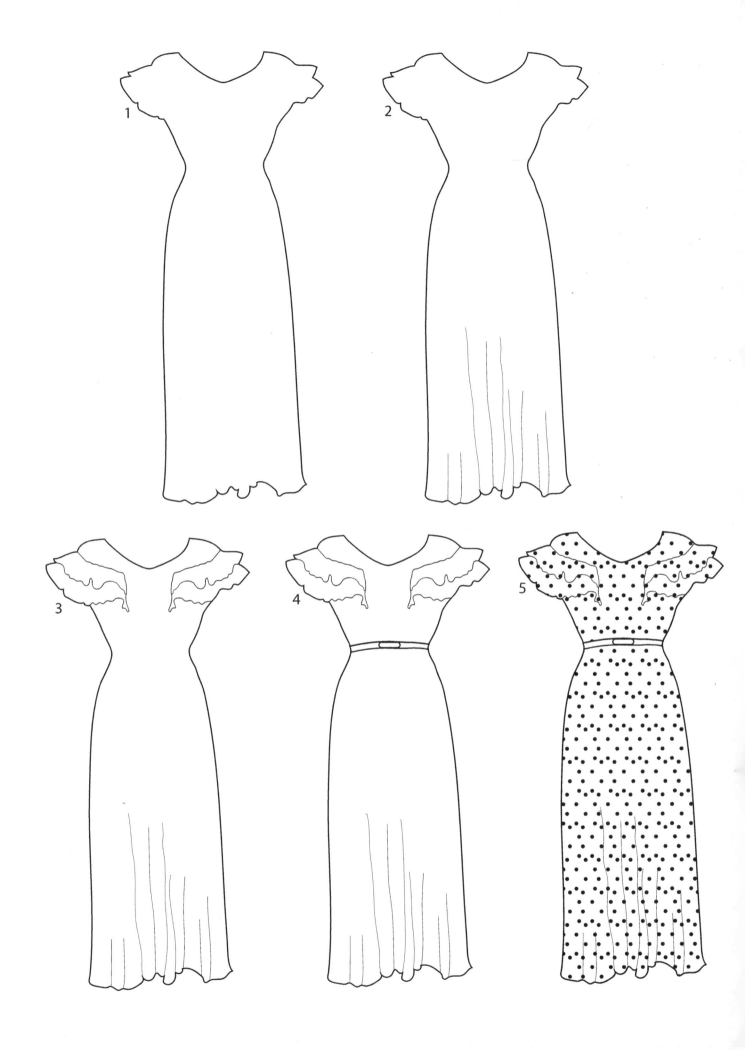

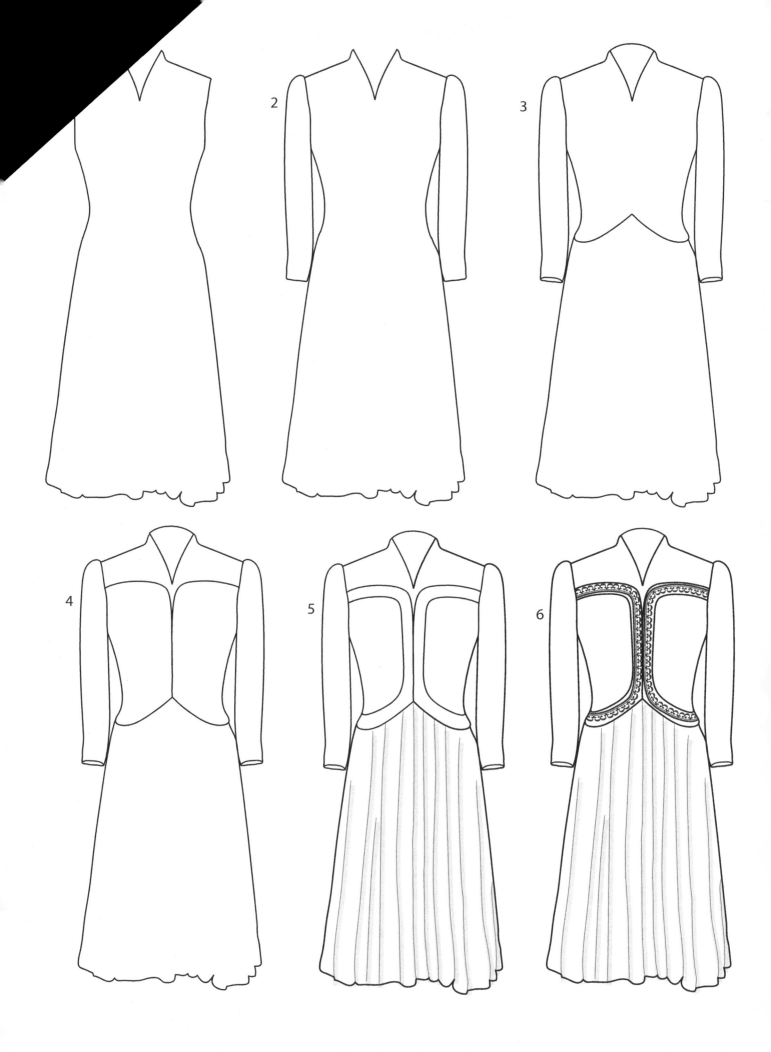

Practice Page

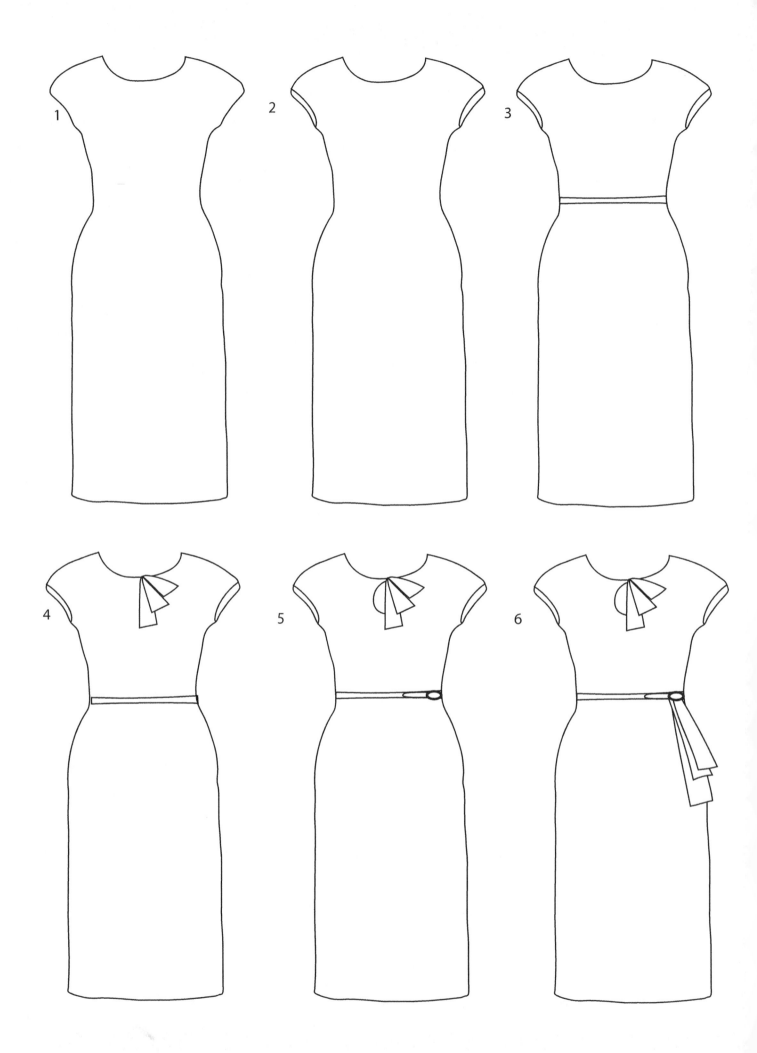

Practice Page

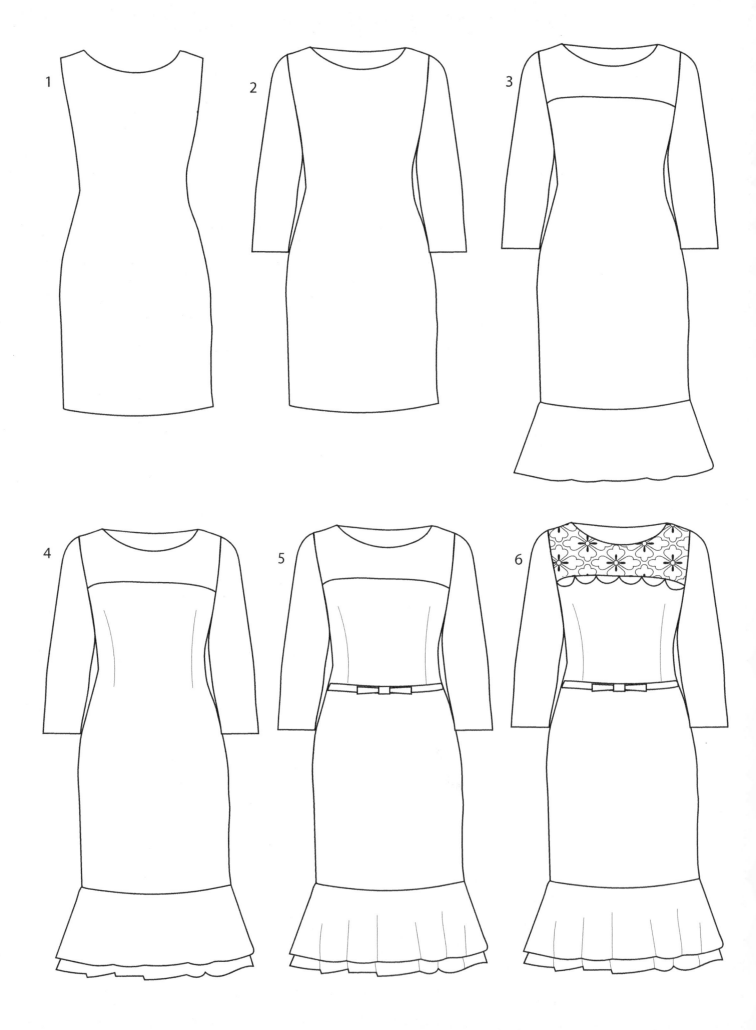

Practice Page

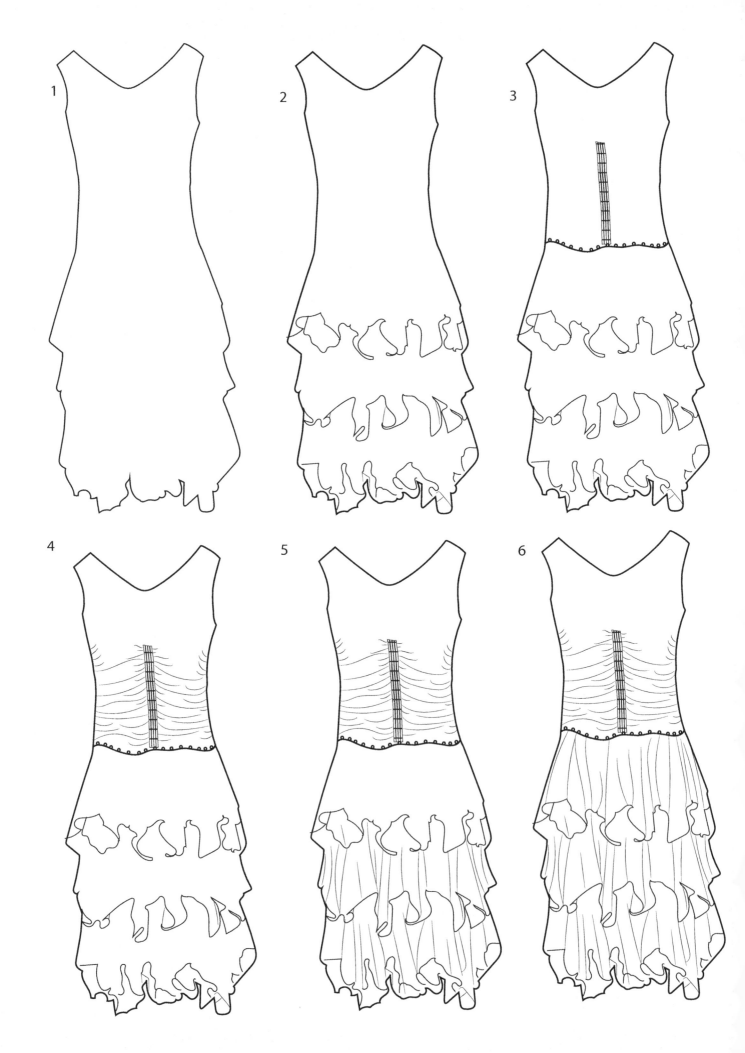

Practice Page

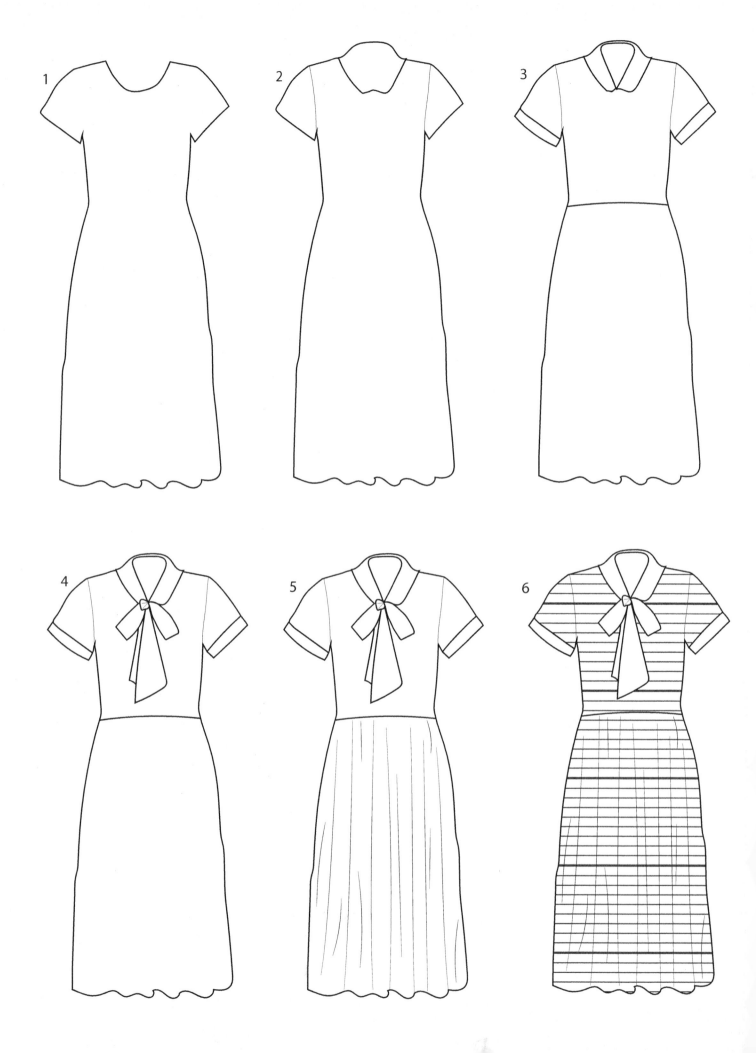

Practice Page

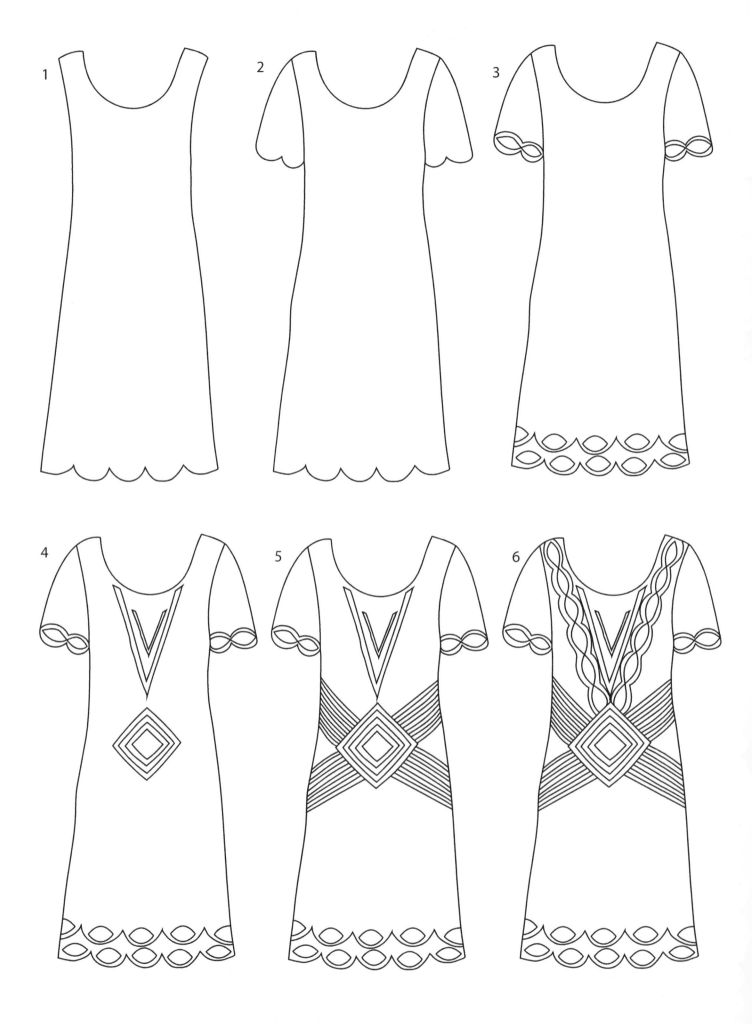

Practice Page

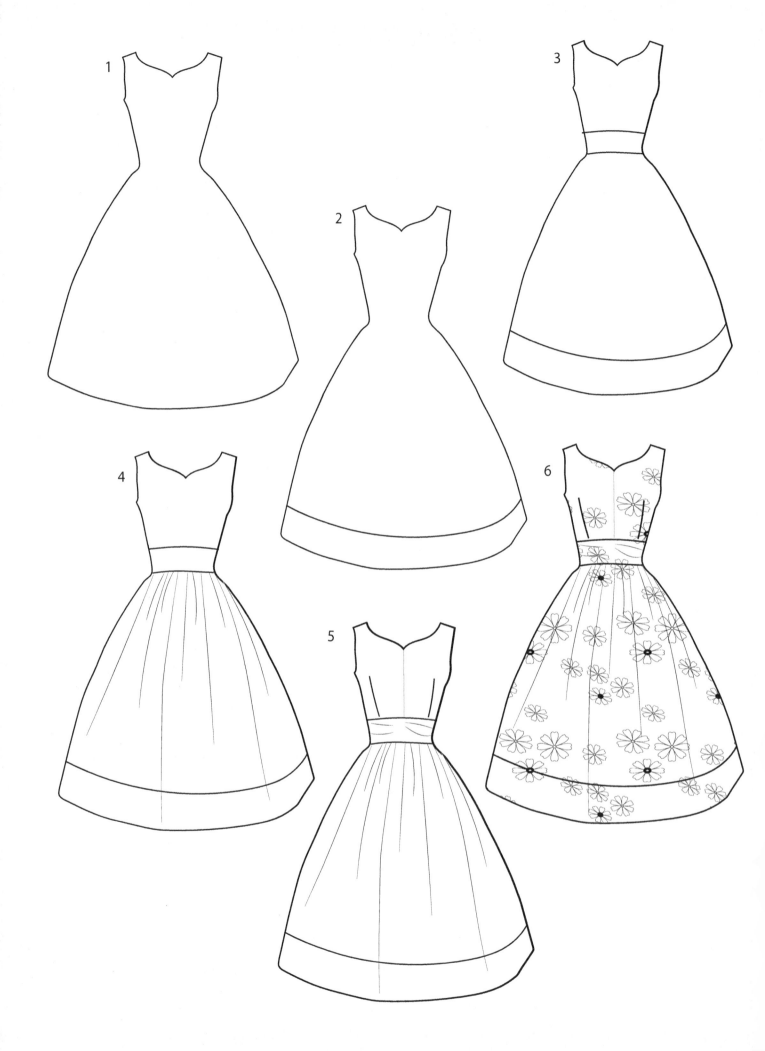

Practice Page

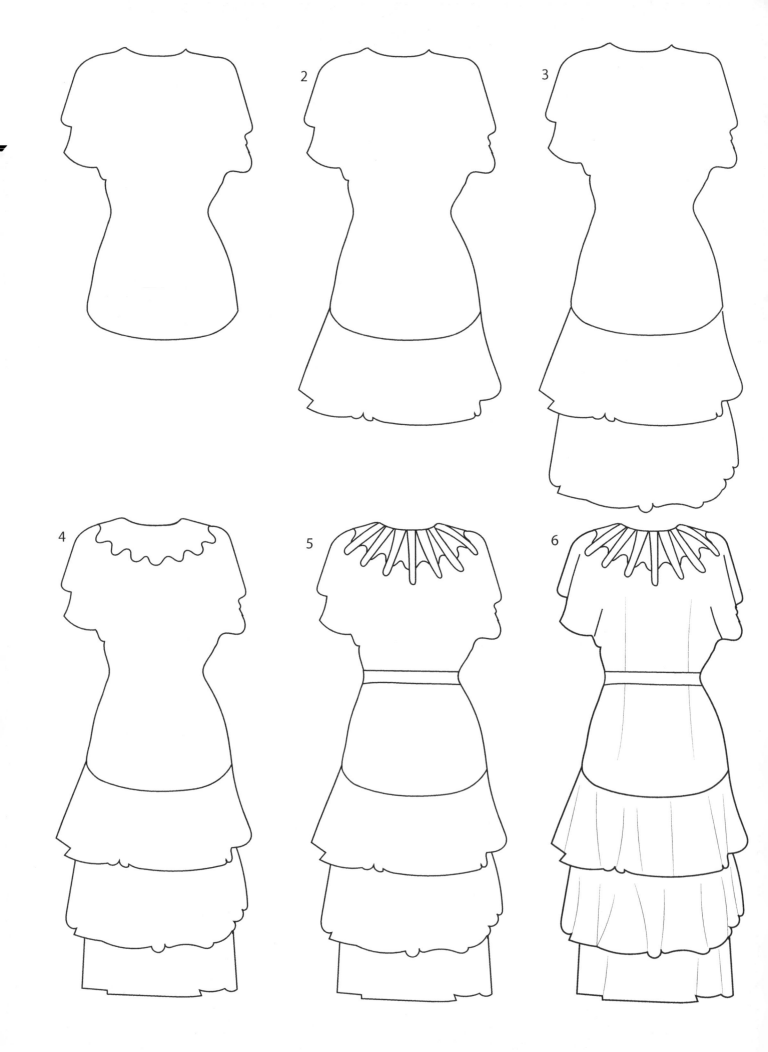

Practice Page

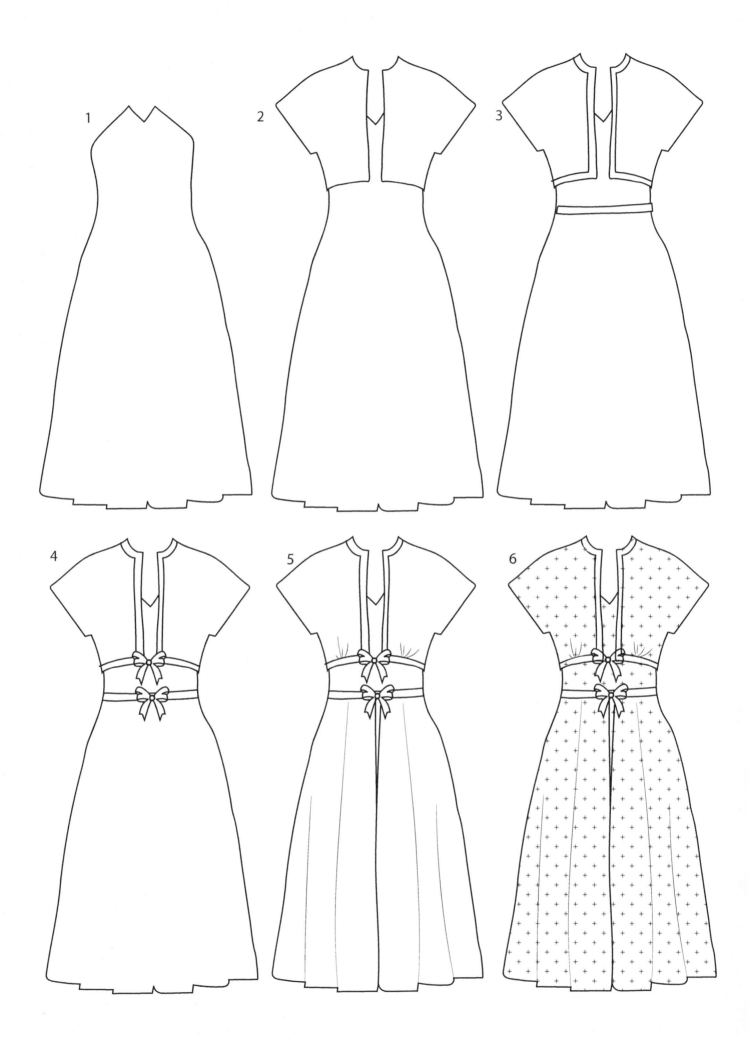

Practice Page

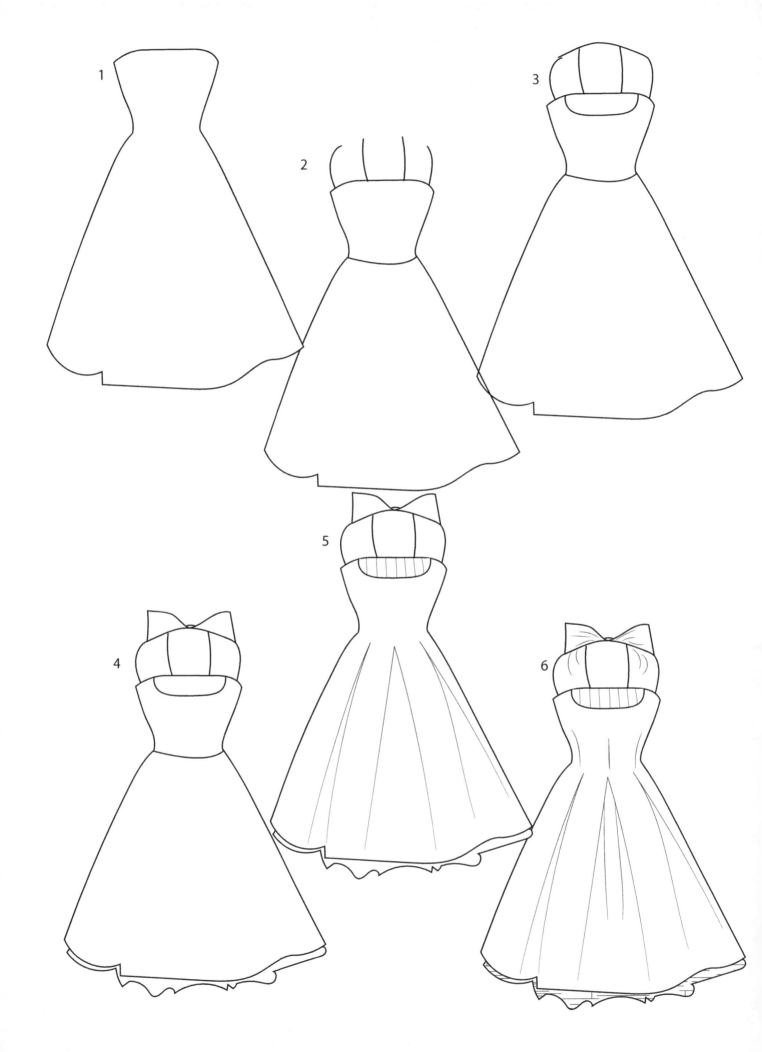

Practice Page

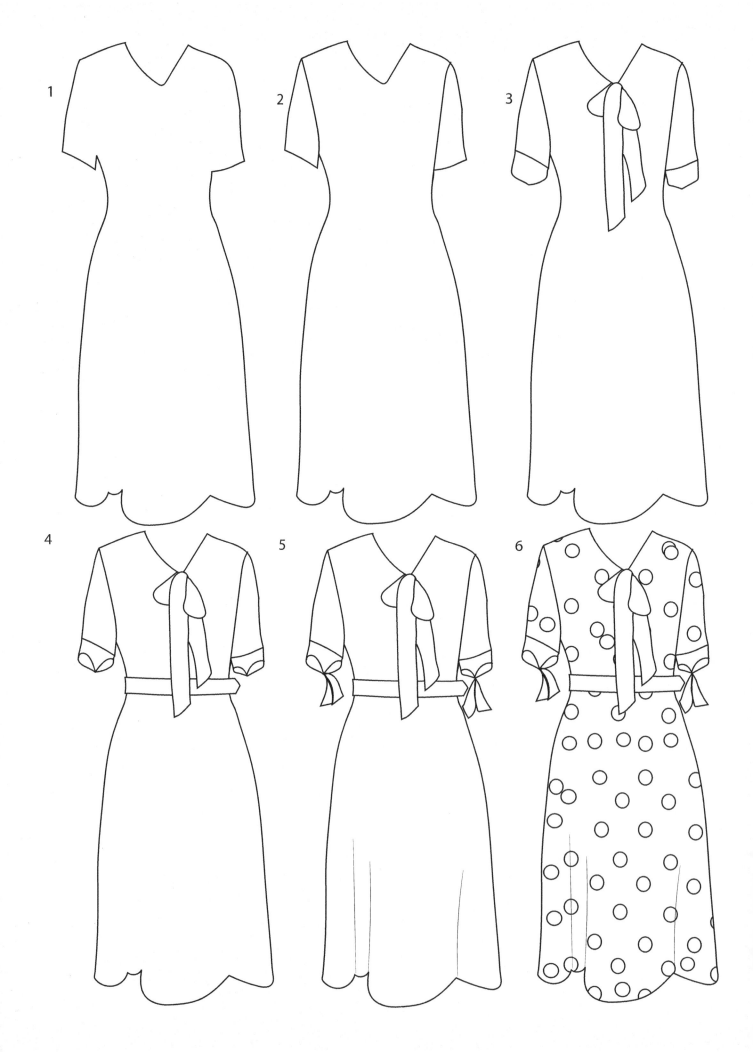

Practice Page

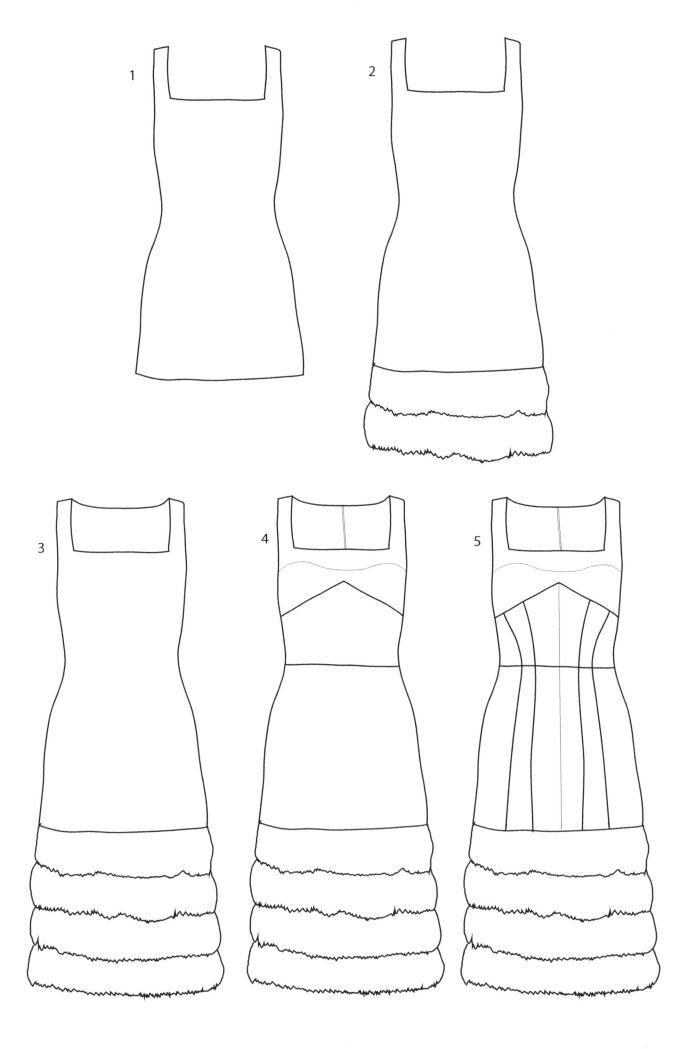

Practice Page

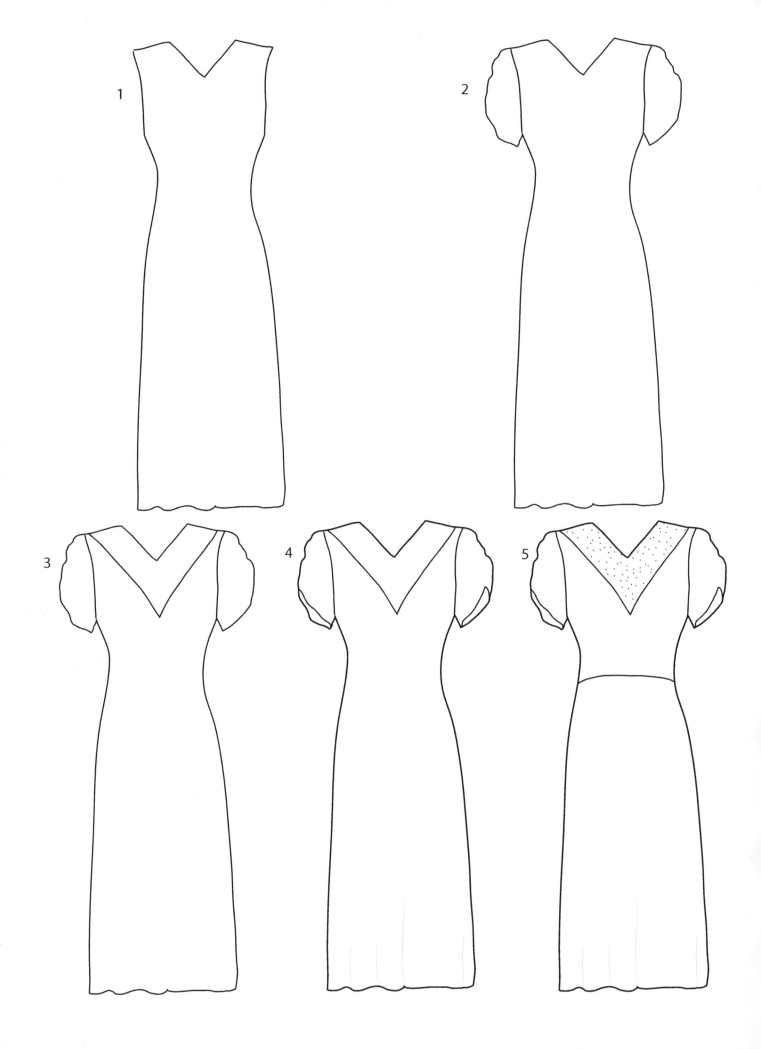

Practice Page

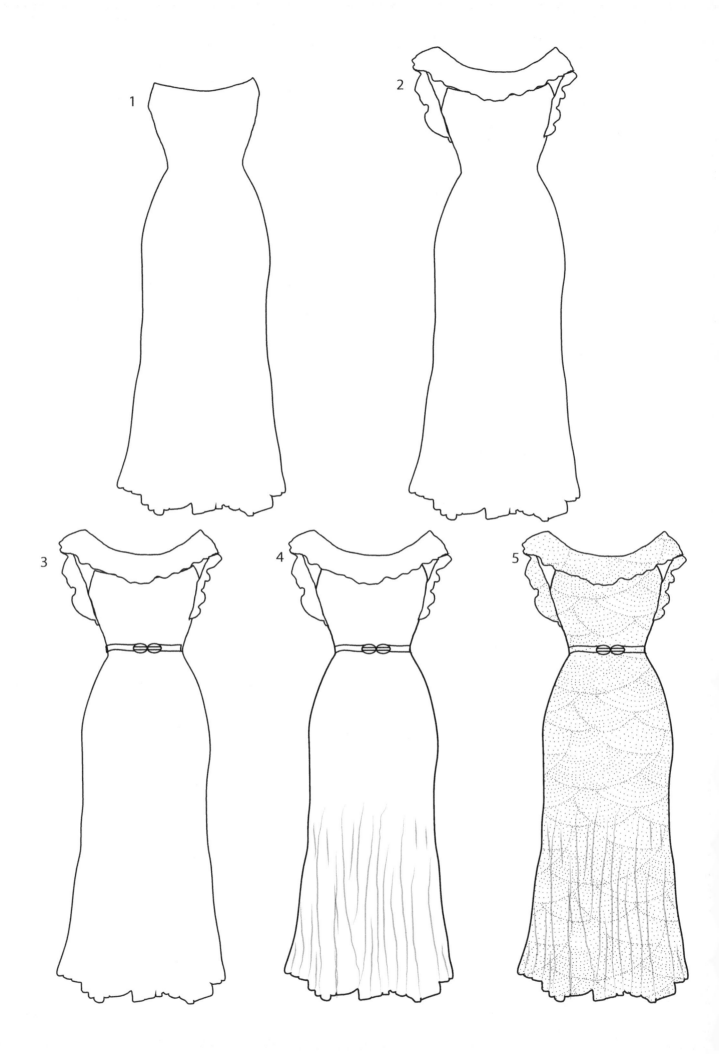

Practice Page

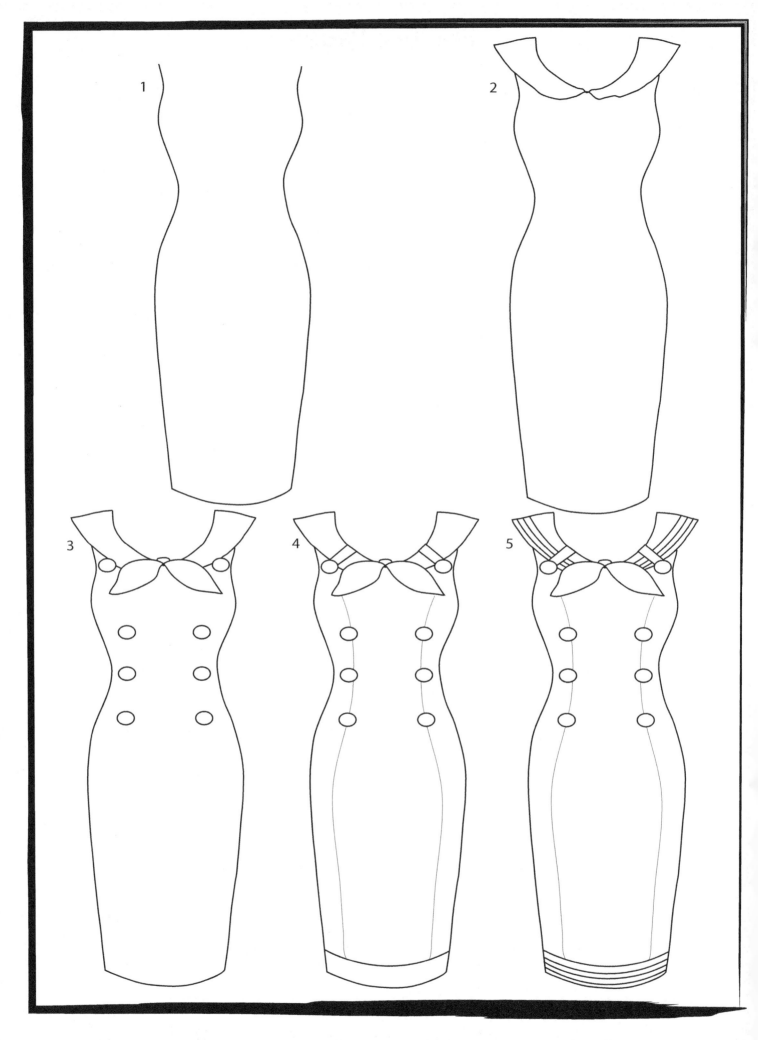

Practice Page

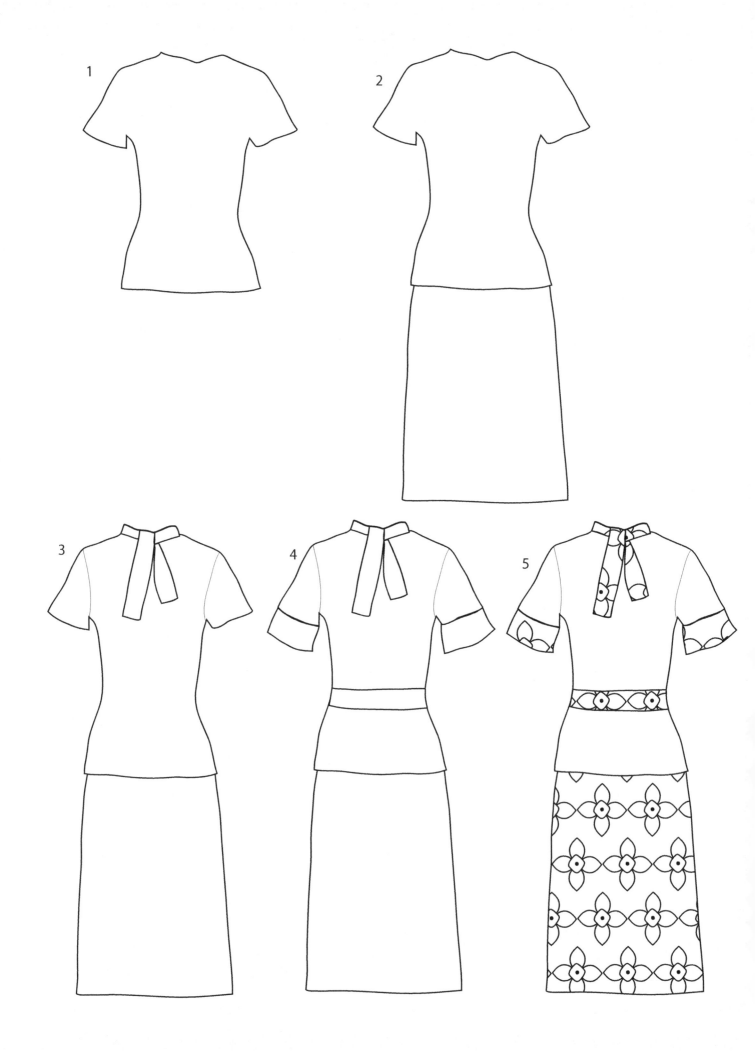

Practice Page

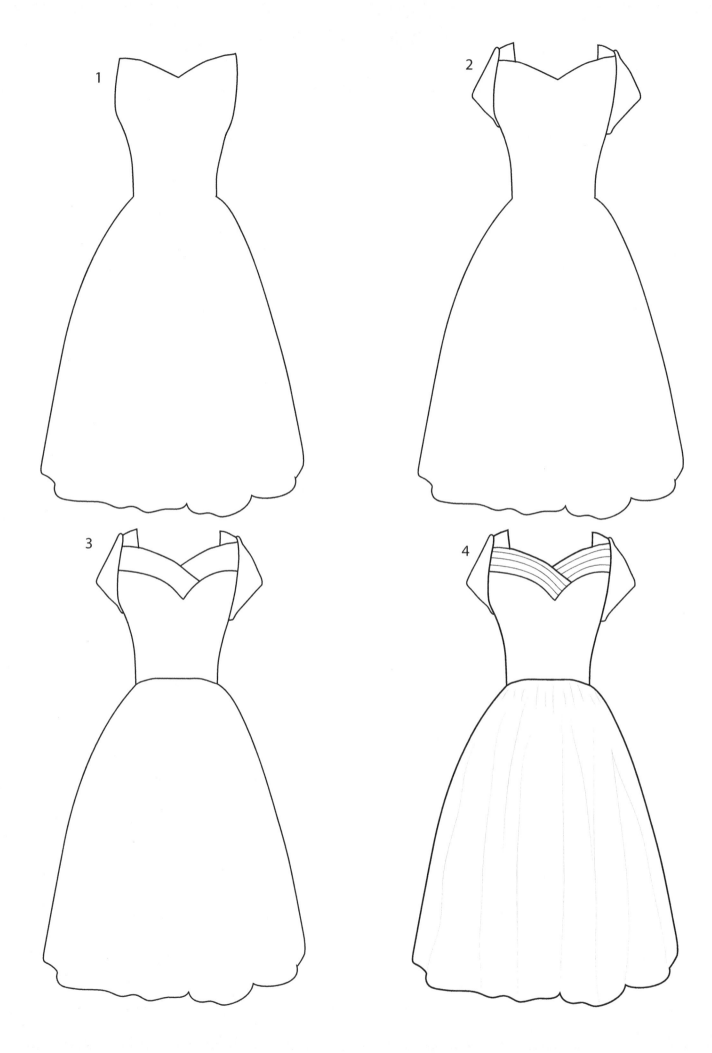

Practice Page

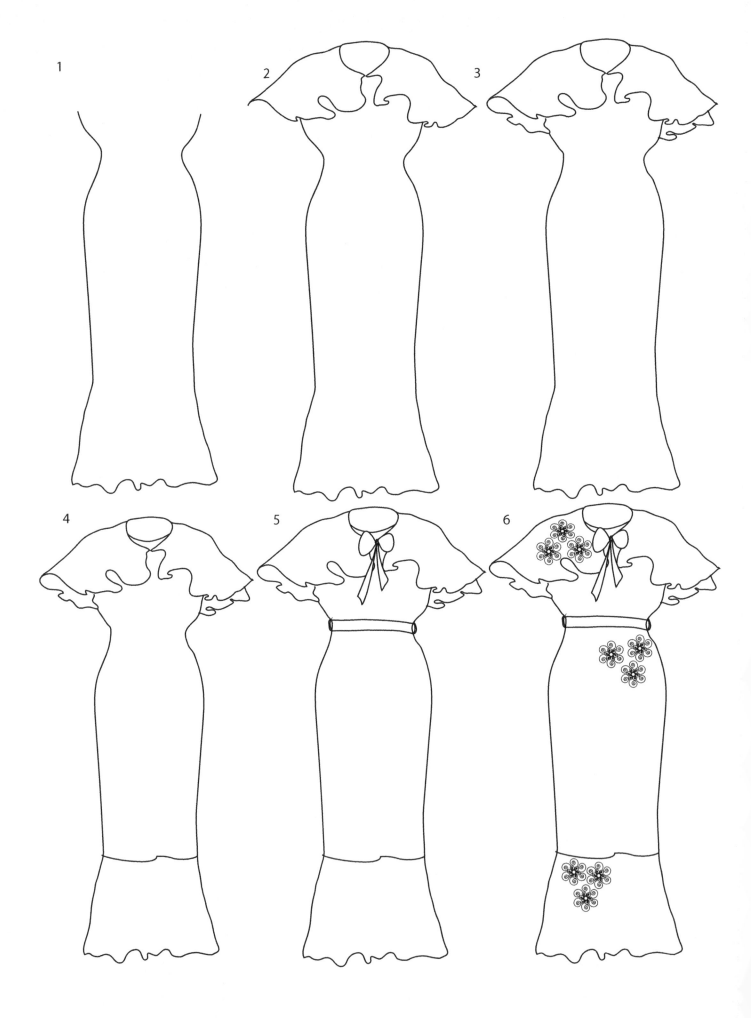

Practice Page

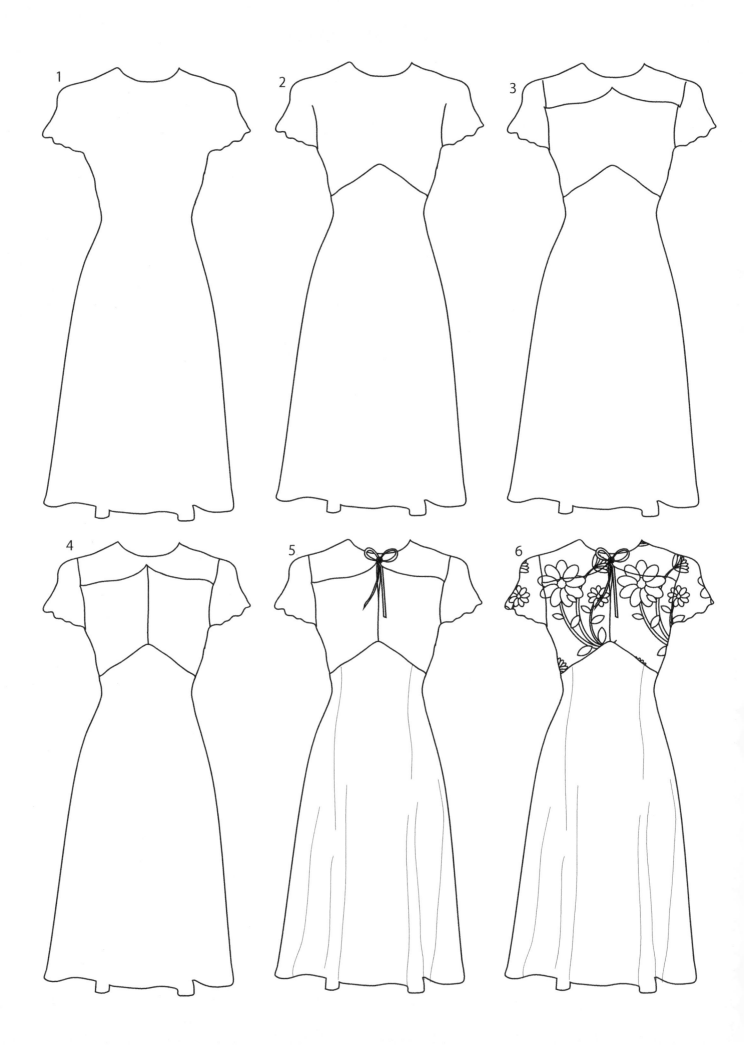

1

2

3

4

5

6

Practice Page

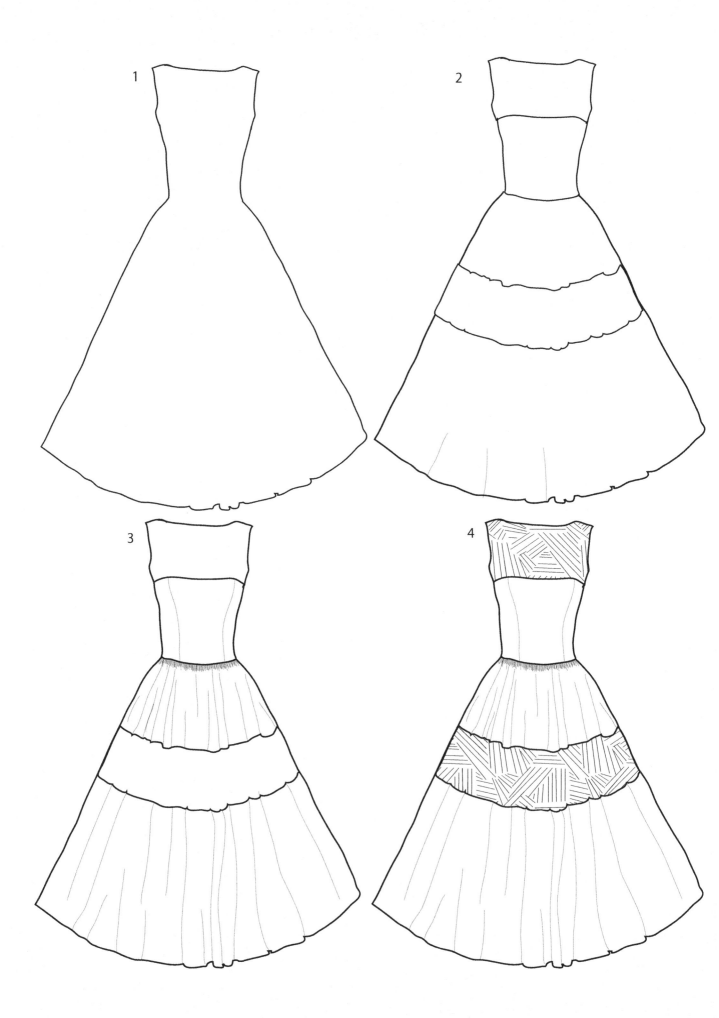

Practice Page

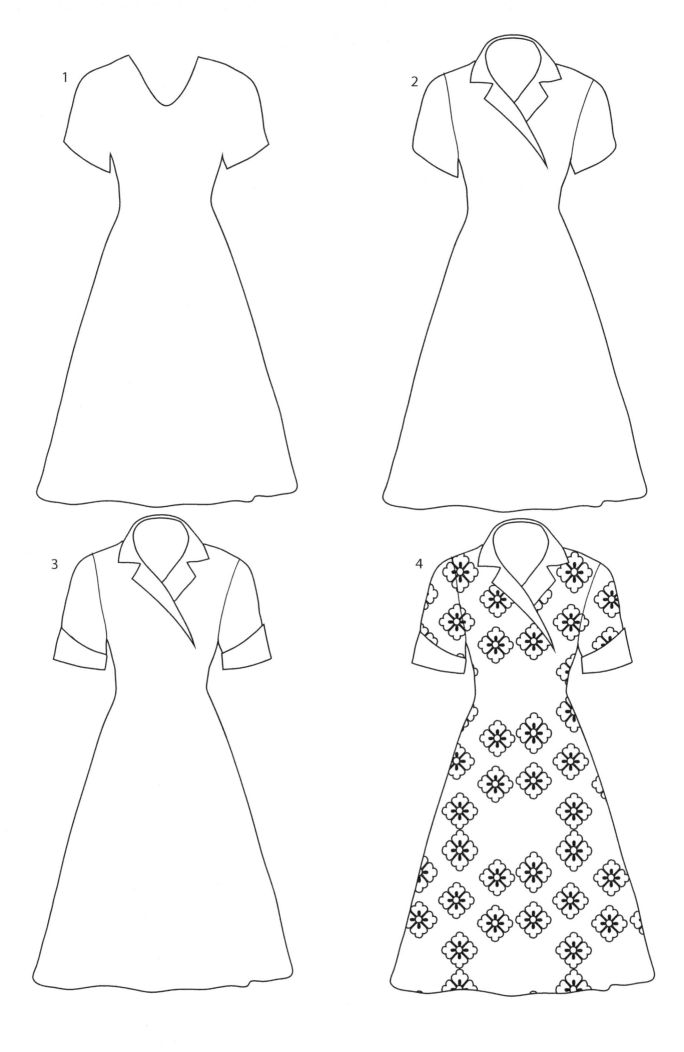

Practice Page

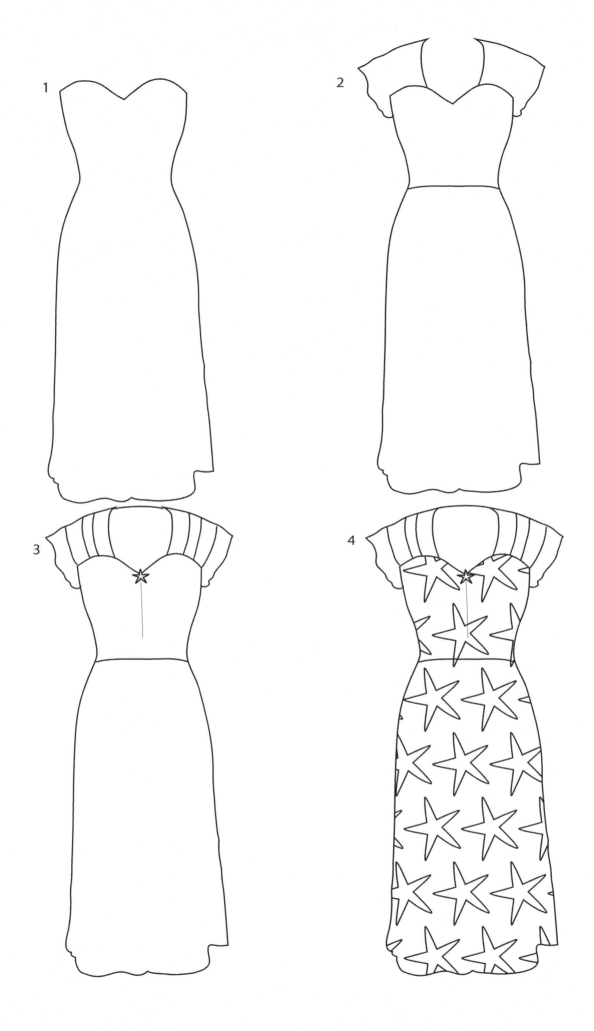

Practice Page

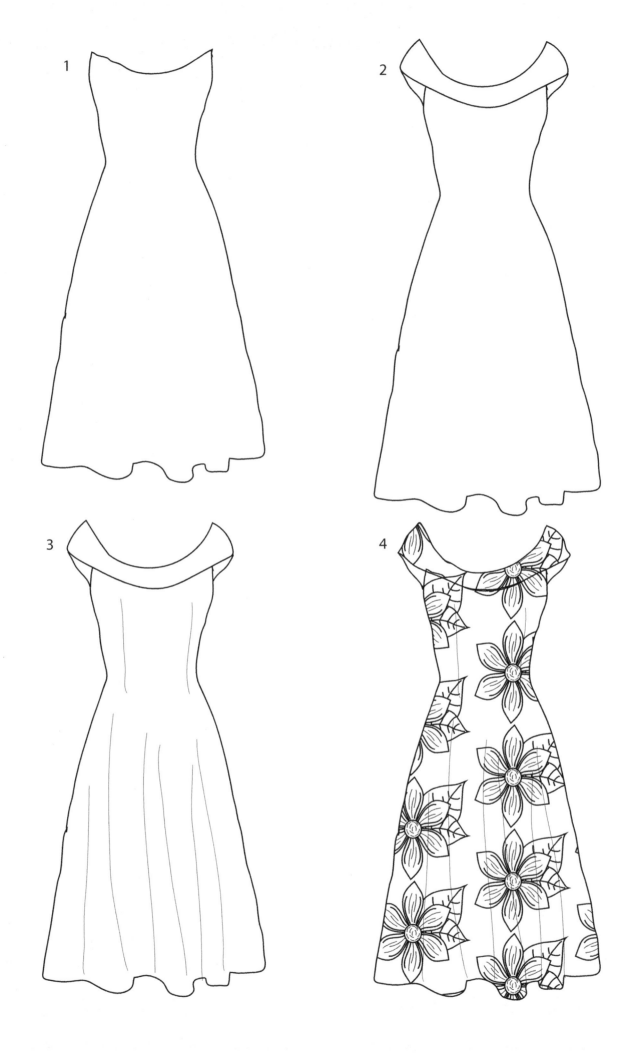

Practice Page

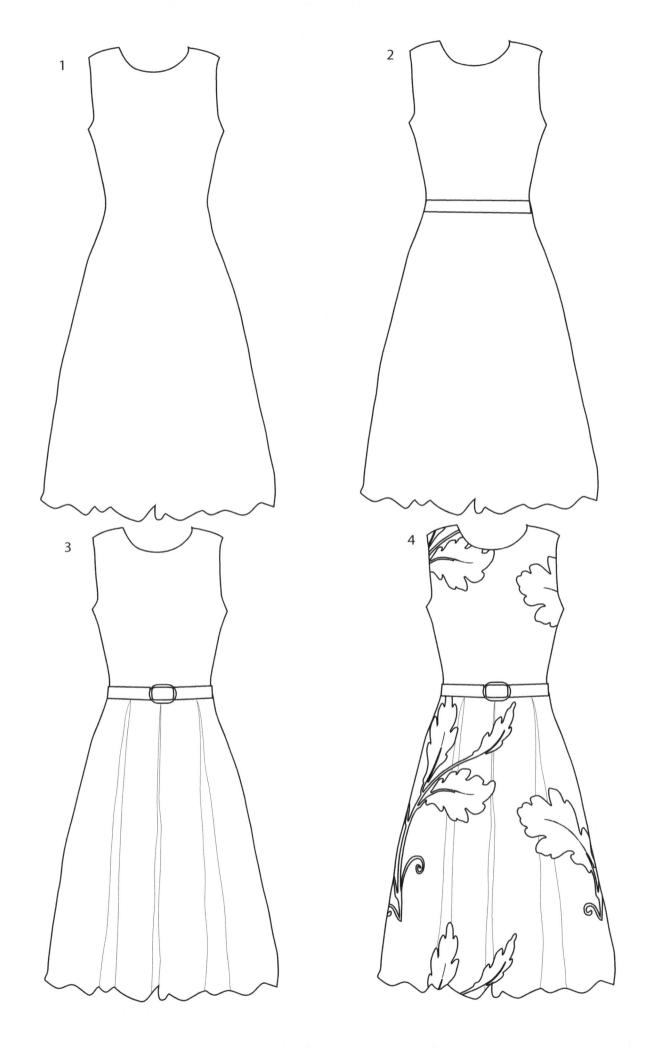

Practice Page

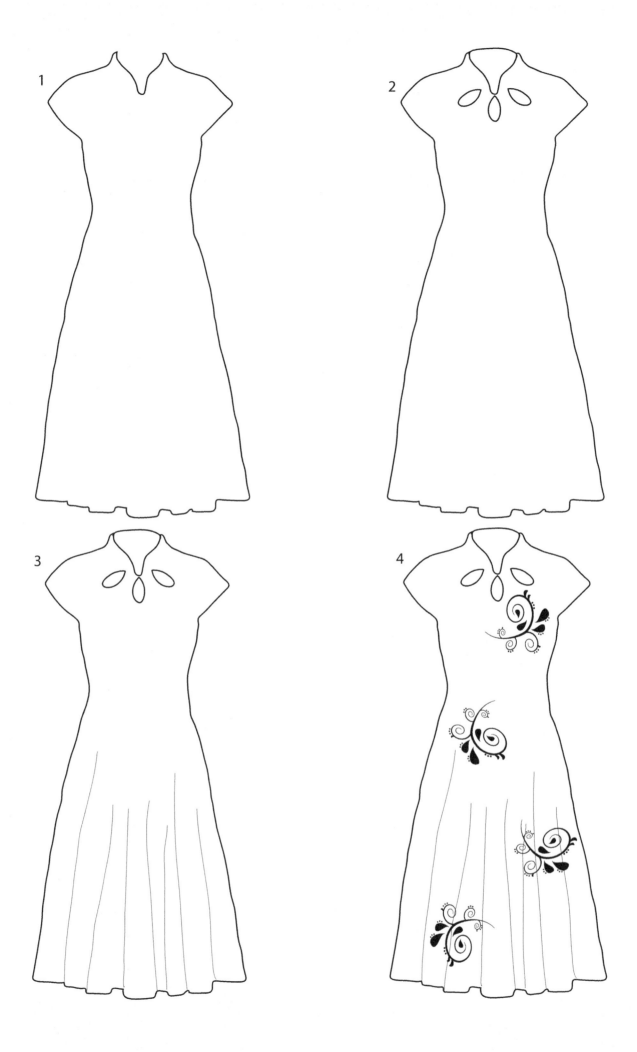

Practice Page

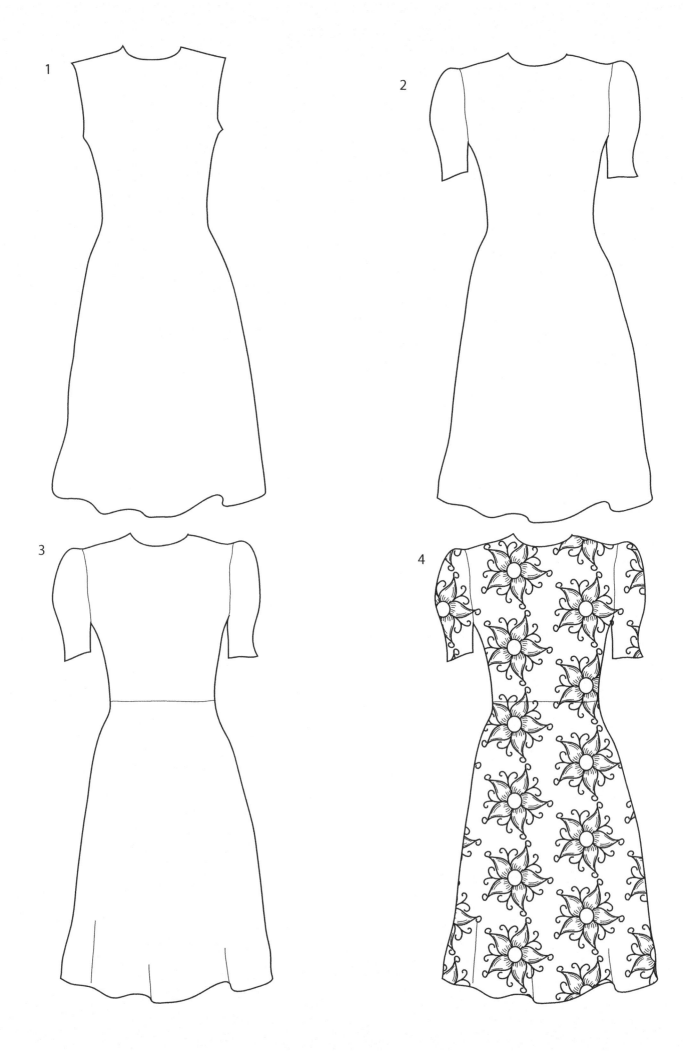

Practice Page

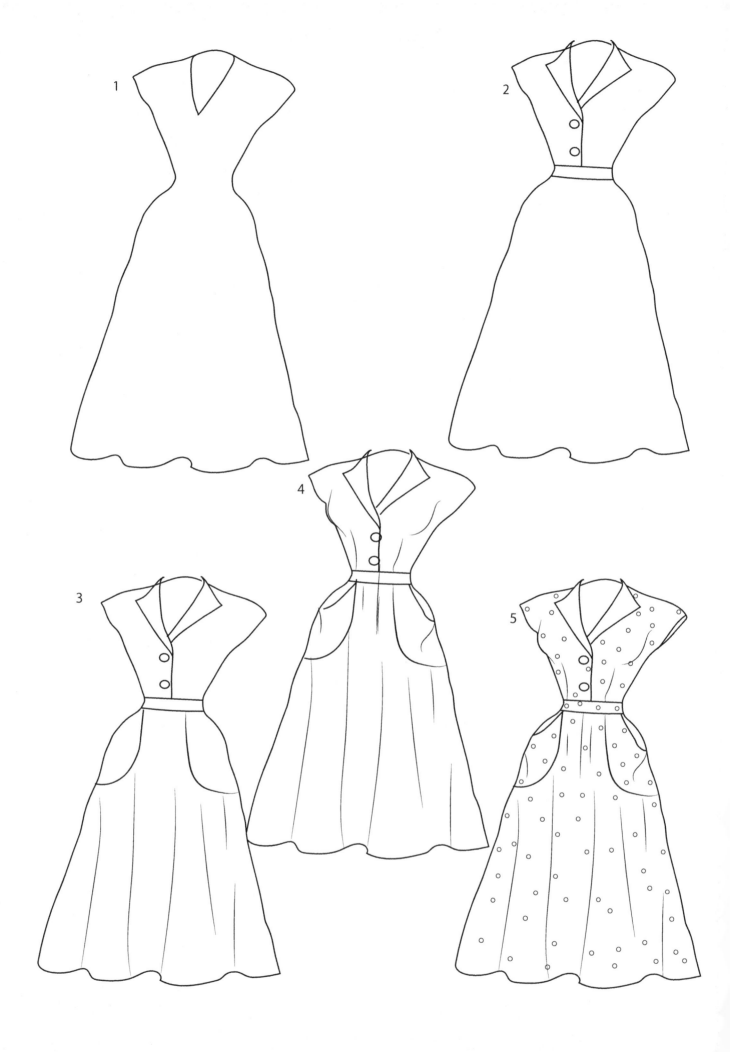

Practice Page

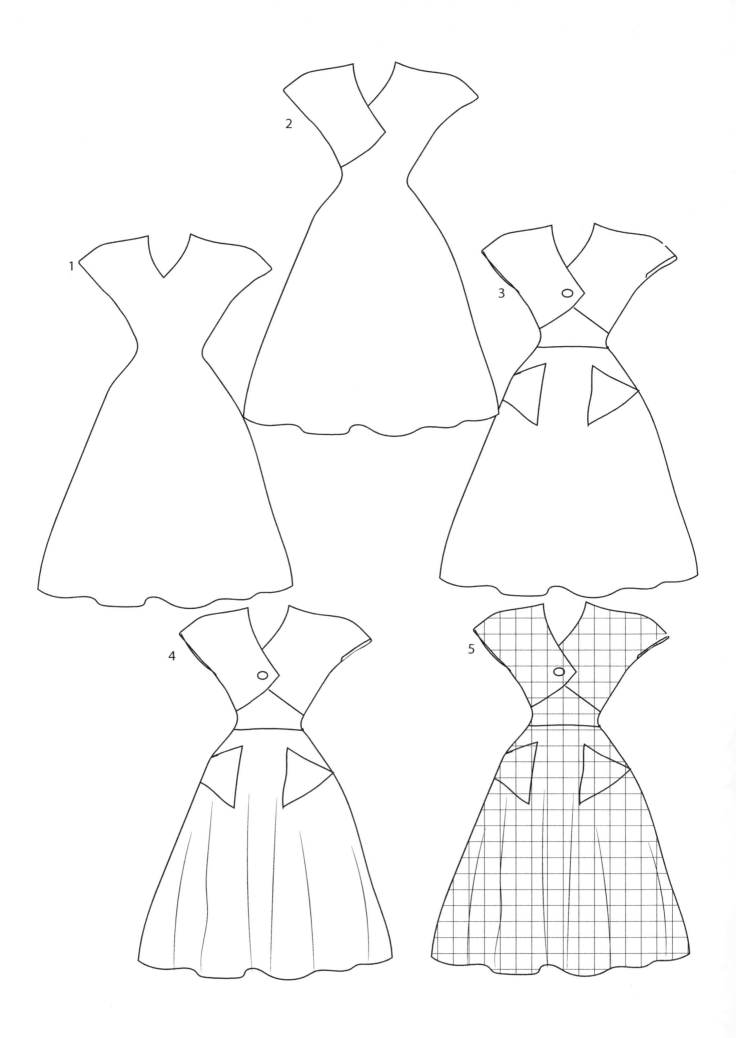

Practice Page

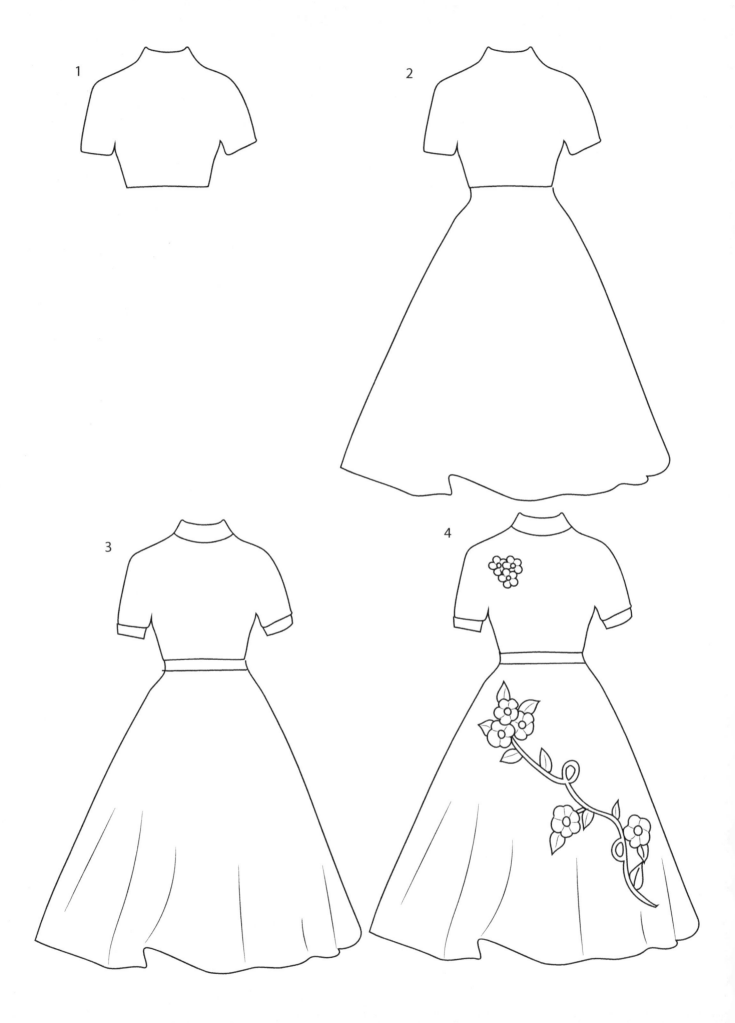

Practice Page

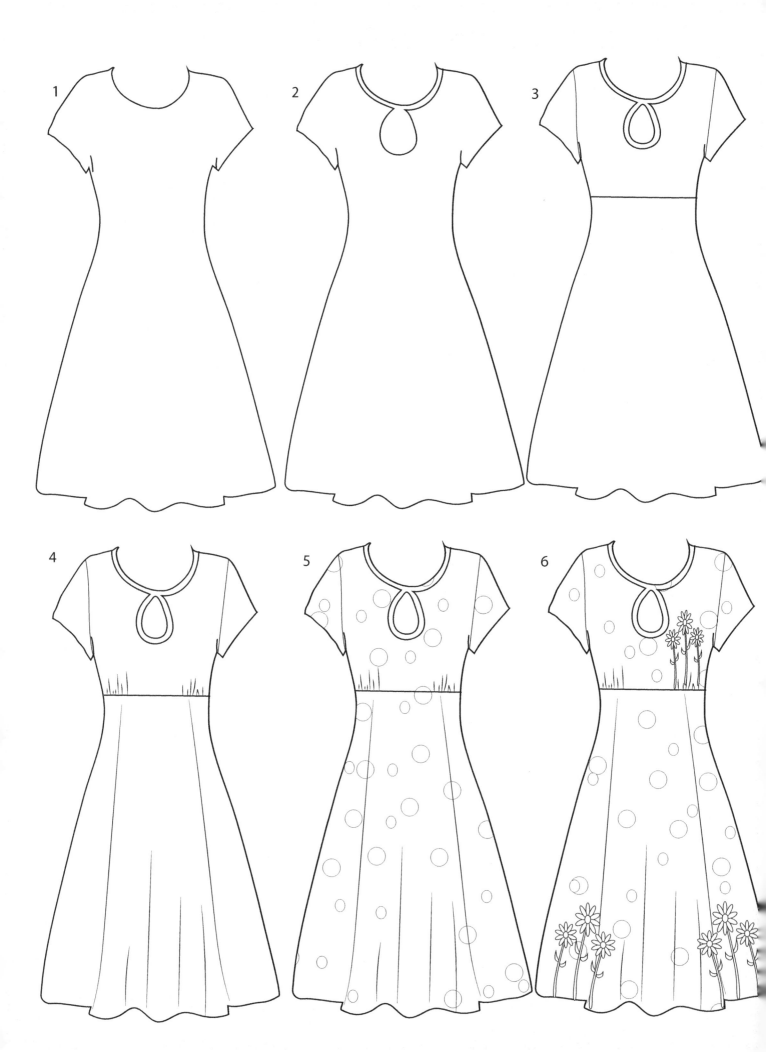

Practice Page

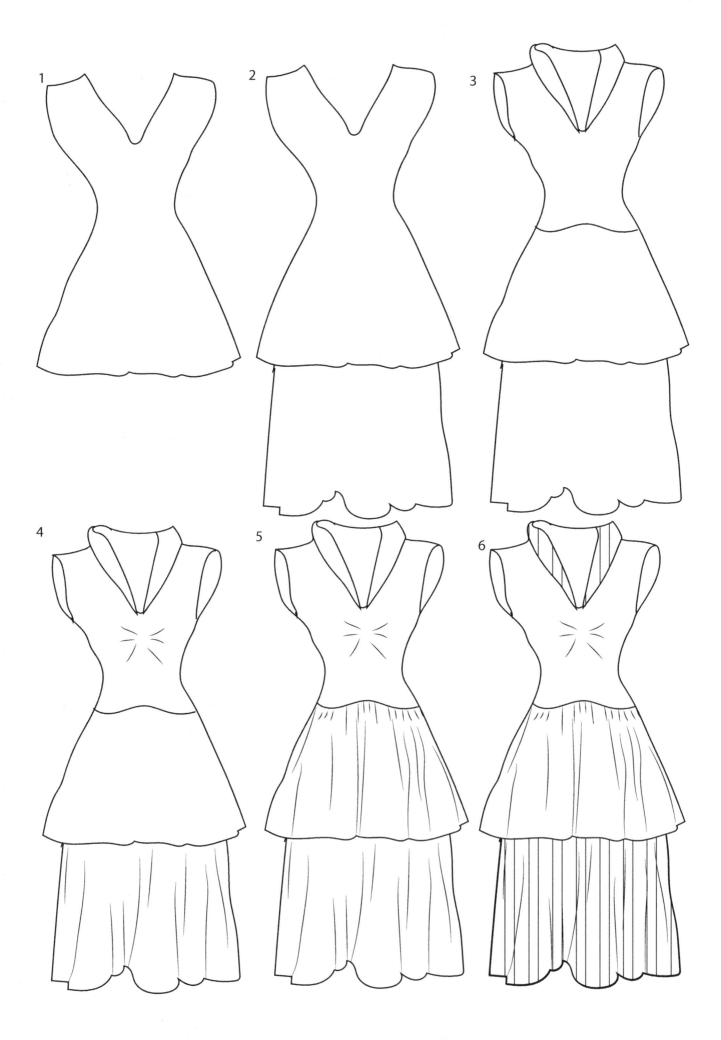

Practice Page

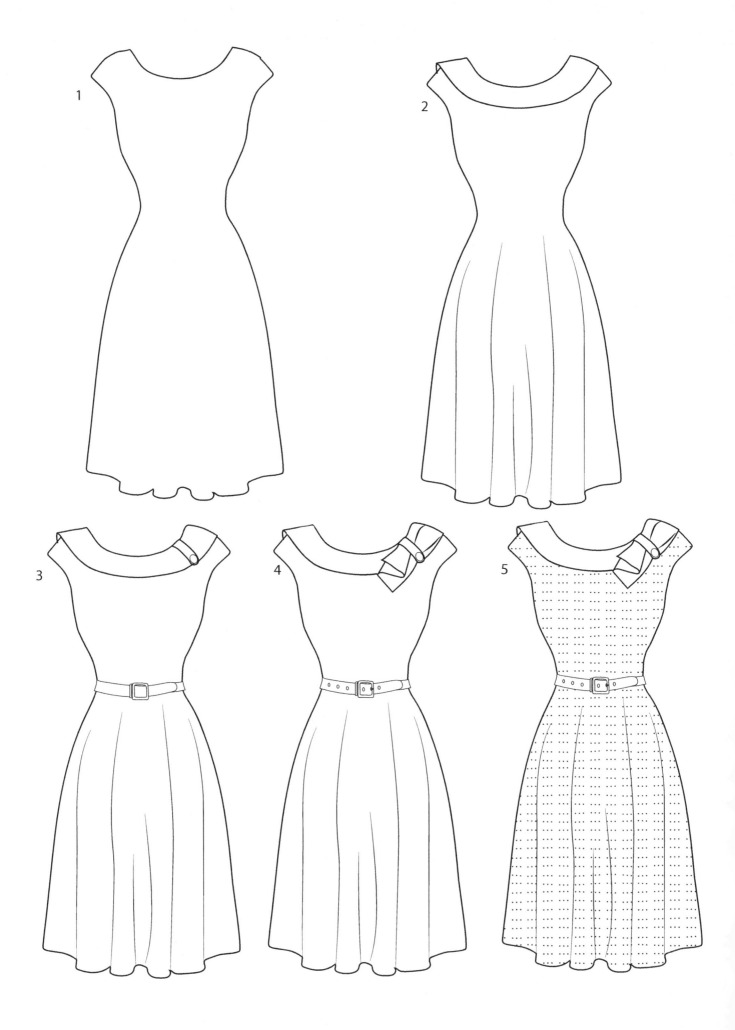

Practice Page

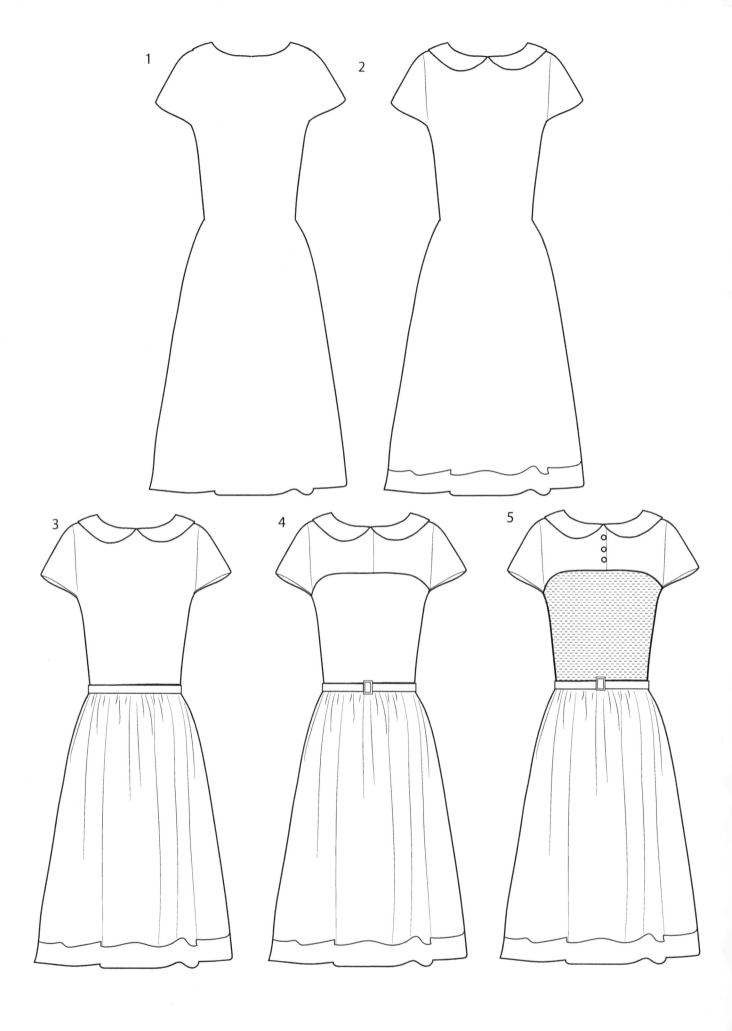

Practice Page

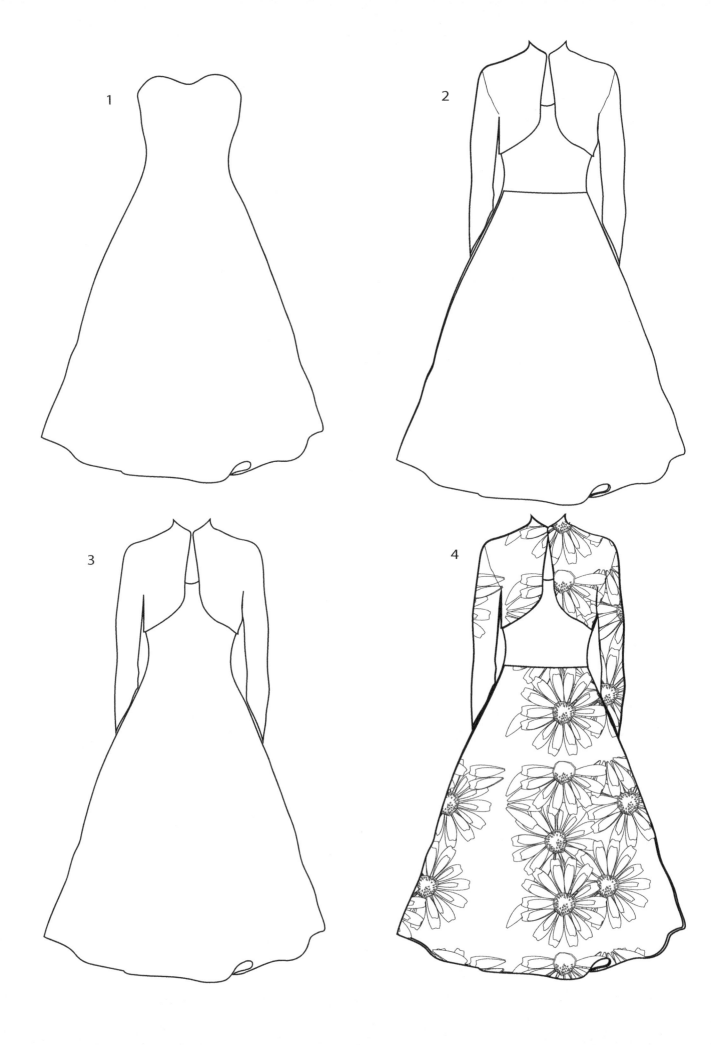

1

2

3

4

Practice Page

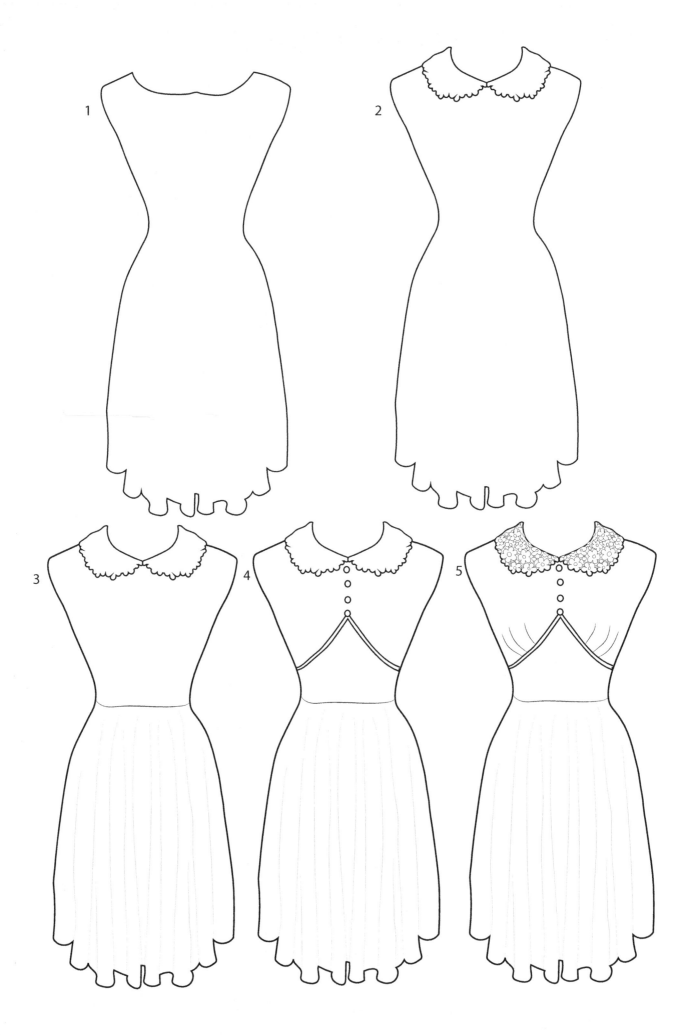

Practice Page

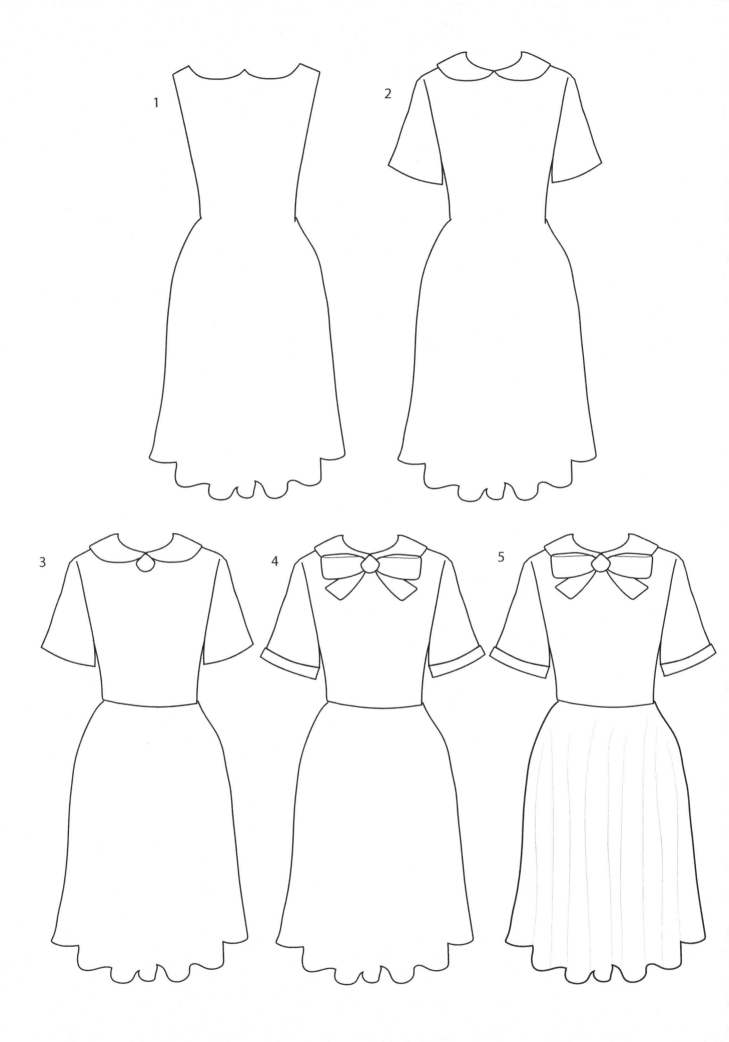

Made in the USA
Coppell, TX
27 October 2020